Curious Cats and Kittens

Coloring for Artists

Skyhorse Publishing

Curious Cats and Kittens:
Coloring for Artists

This coloring book has been crafted with the artist in mind; its feline designs have been chosen for the sophisticated hand and the discerning palette. Not to be discounted as a lesser art form, coloring is a wonderful way to exercise your creativity and relieve stress. To further entice you to do so, we can think of no better subject than the svelte creatures that have been revered since antiquity. Cats have long enchanted their human counterparts and have come to represent many different things. In Europe, lions have been emblazoned on royal crests for centuries as icons of courage and power. Tigers have featured heavily in East Asian art, depicted as the fierce hunters they are. Even the smaller breeds have been granted special symbolism. The Egyptians regarded cats with a religious respect, honoring them for their utility in pest control as well as their obvious beauty. In many cultures, black cats are synonymous with magic and strange forebodings. The mysterious black cat is even the namesake and mascot of Le Chat Noir, the famous nineteenth-century Paris nightclub often credited as the first modern cabaret. What better way to usher in an era of whispered affairs and scandal than with one of our most furtive animal icons?

Beyond these widely recognized tropes, cats have featured as the inspiration and honorees of various art forms. Let's take a stroll through European history. Dutch artist Cornelis Visscher's engraving *The Large Cat* was the seventeenth century's most famous piece of feline art. Cats served as subjects of Hungarian-German painter Arthur Heyer's animal portraits in the late eighteenth century. They were also the muses of poetry and faerie tales. In John Keats's "Mrs. Reynold's Cat," a household feline is praised for her hunting skills, vivacity, and beauty despite physical deformities and abuse at the hands of the maid.

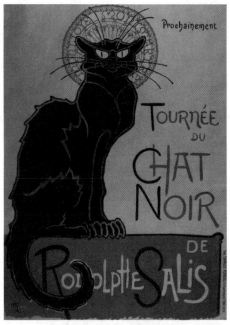

Théophile Steinlein's poster advertising Le Chat Noir's cabaret entertainers' tour of other cities (1896)

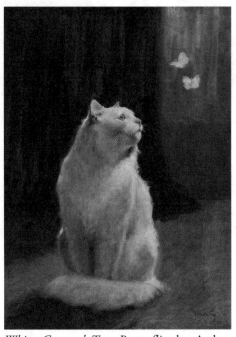

White Cat and Two Butterflies by Arthur Heyer (late 1800s–early 1900s)

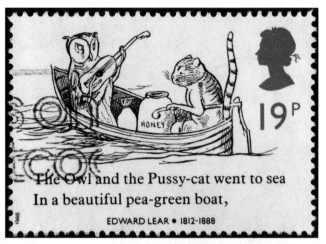

British postage stamp depicting Edward Lear's "The Owl and the Pussycat" (c. 1988)

The unfortunate demise of a beloved cat is narrated in "Ode on the Death of a Favourite Cat" by Thomas Gray. Edward Lear's nonsense ballad, "The Owl and the Pussycat," makes use of a delightfully lilting rhyme scheme to tell the tale of the titular characters' elopement. And who can forget the adventures of Puss in Boots—the sly cat who stole his fancy footwear, along with hat and sword, from an unsuspecting bather. The tale of this cunning feline was first recorded in the 1500s by Giovanni Francesco Straparola but most likely goes back even further in European folklore. Not too long ago, Puss's celebrity experienced a revival thanks to the *Shrek* movie franchise, extending this infamous cat's longevity far beyond the typical nine lifespans and continuing to inspire artistic renditions today.

In summary, whether they're the highlight of a story or the focal point of a painting, cats have long held our affectionate attentions. As of 2016, in the United States alone, nearly 43 million households have pet cats, and the number of those cats is nearly 86 million. In recent years, cats have roamed beyond their domestic homes to the wilds of the internet, becoming overnight meme sensations and dominating YouTube with their exceptional knack for odd behavior. Clearly, our love of cats hasn't dwindled over the centuries; they're just as charming and useful as they were when the ancient Egyptians revered them. Thus we've curated a lovely collection of feline designs for you to color. Carefully selected for the artist's capability, the pages of this coloring book will provide you with hours of entertainment. You'll find that each page is perforated, conveniently removable to better facilitate your coloring experience. When you're finished with your masterpiece, you can place it on display. So gather your colored pencils, get comfortable, and enjoy.

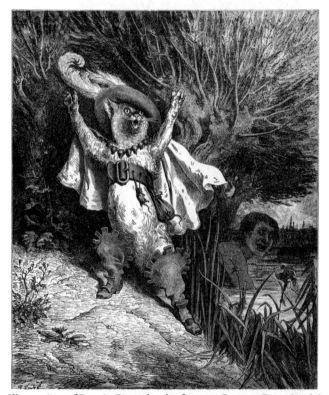

Illustration of Puss in Boots by the famous Gustave Doré (1862)

1

2

3

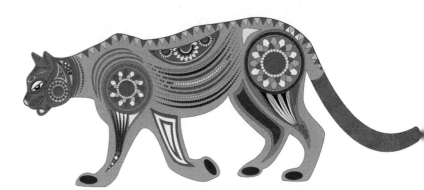

4

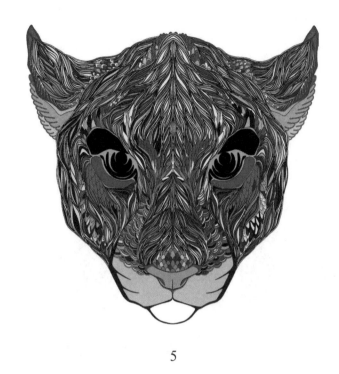

5

6

7

8

9

10

11

12

13

14

15

16

17

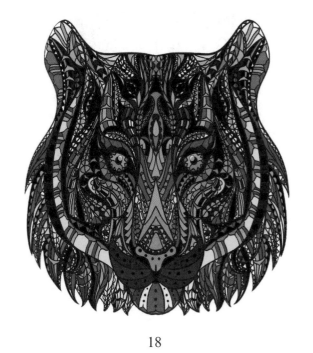

18

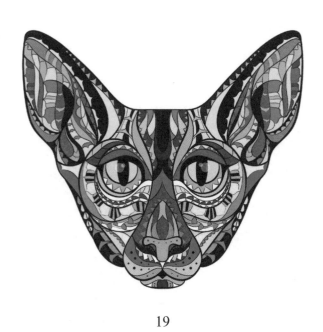

19

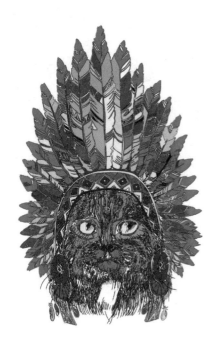

20

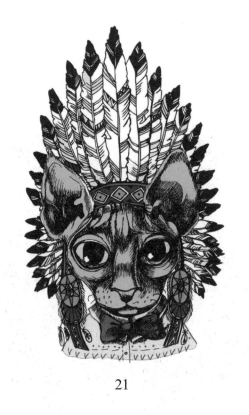

21

22

23

24

25

26

27

28

29

30

31

32

33

34

35

36

37

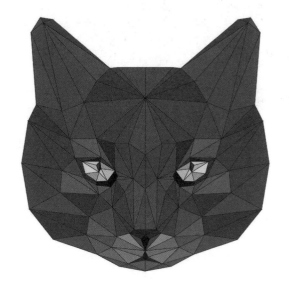

38

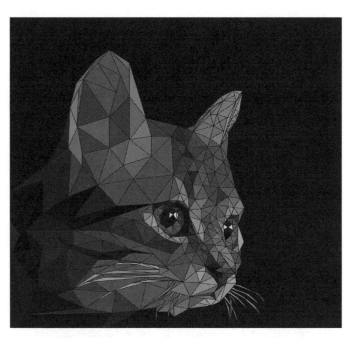

39

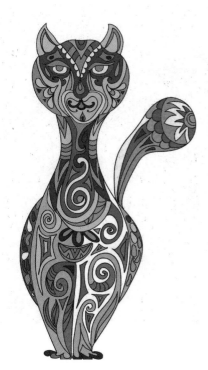

40

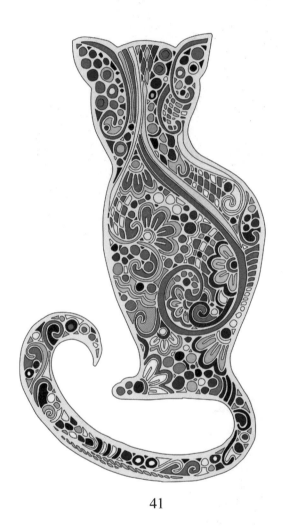

41

42

43

44

45

46

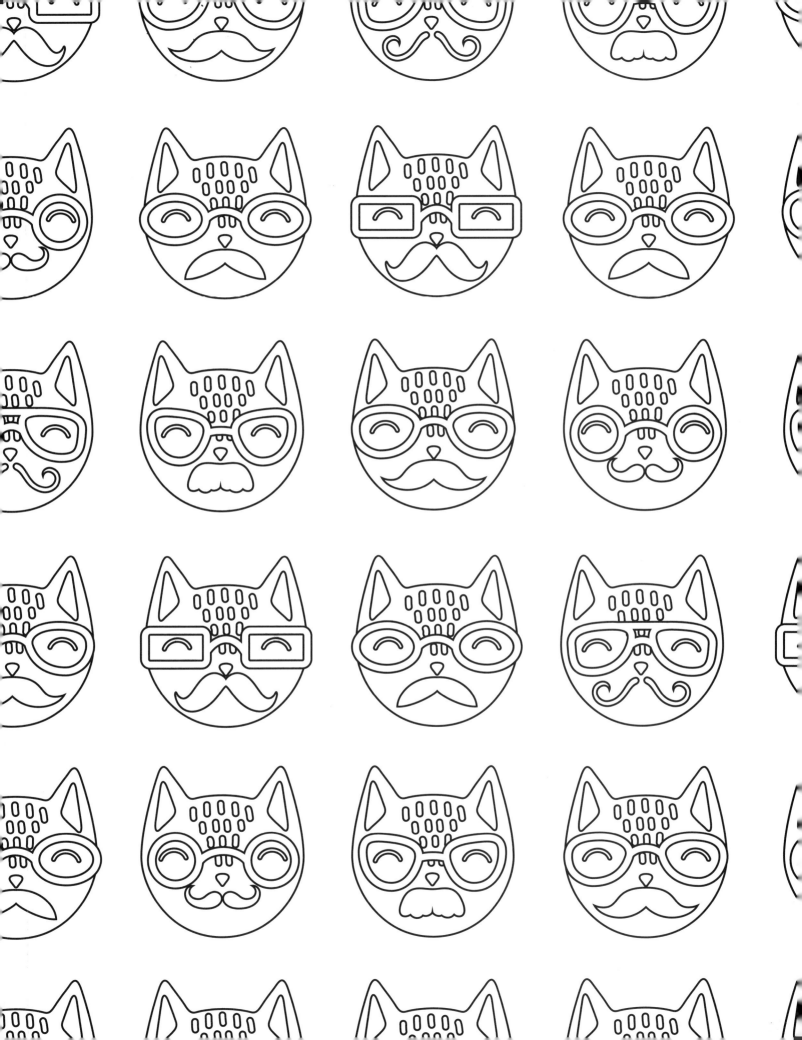

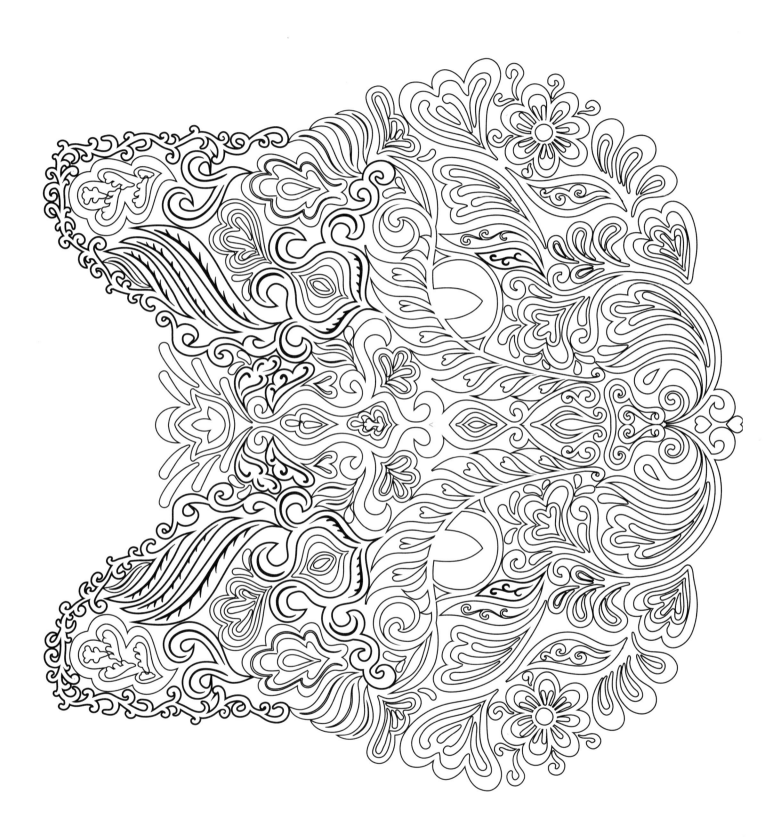

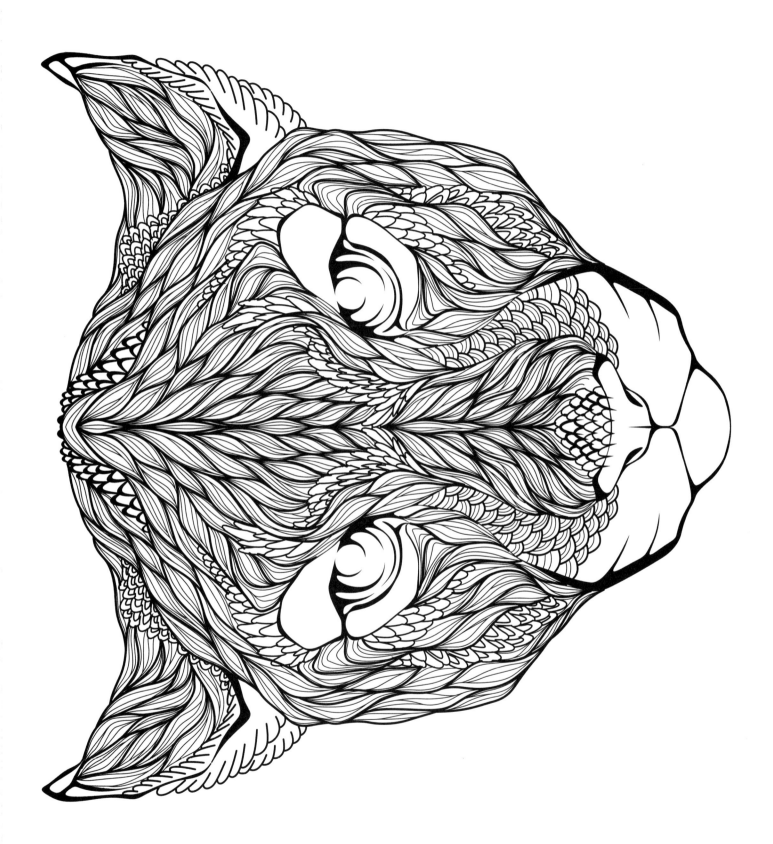

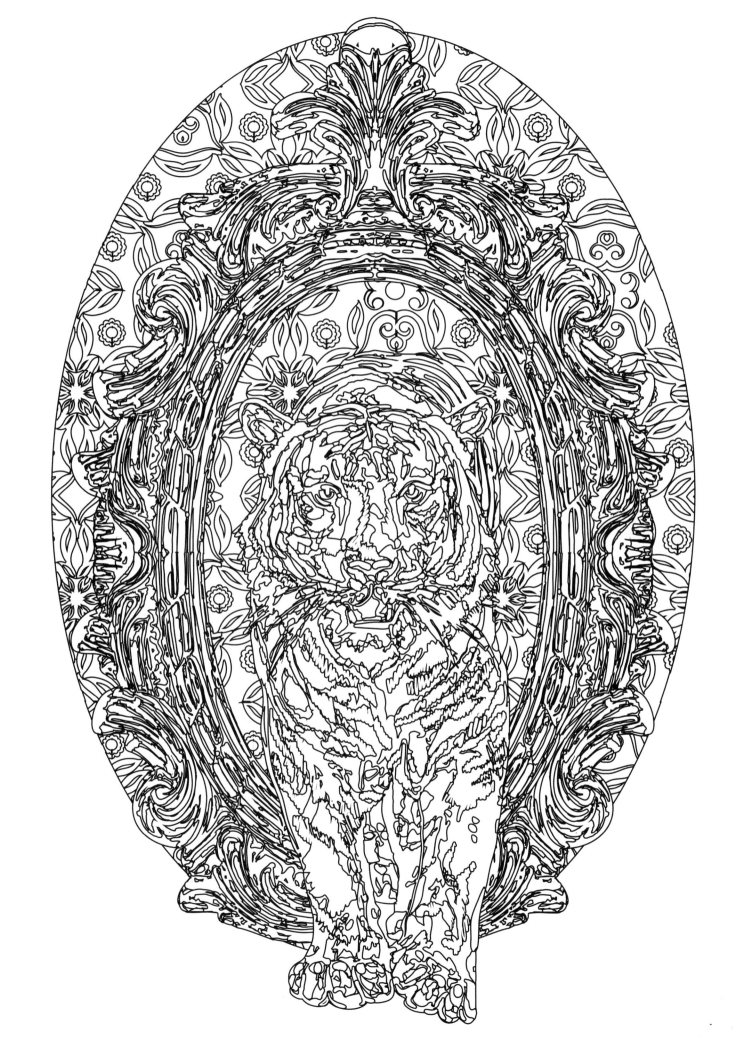

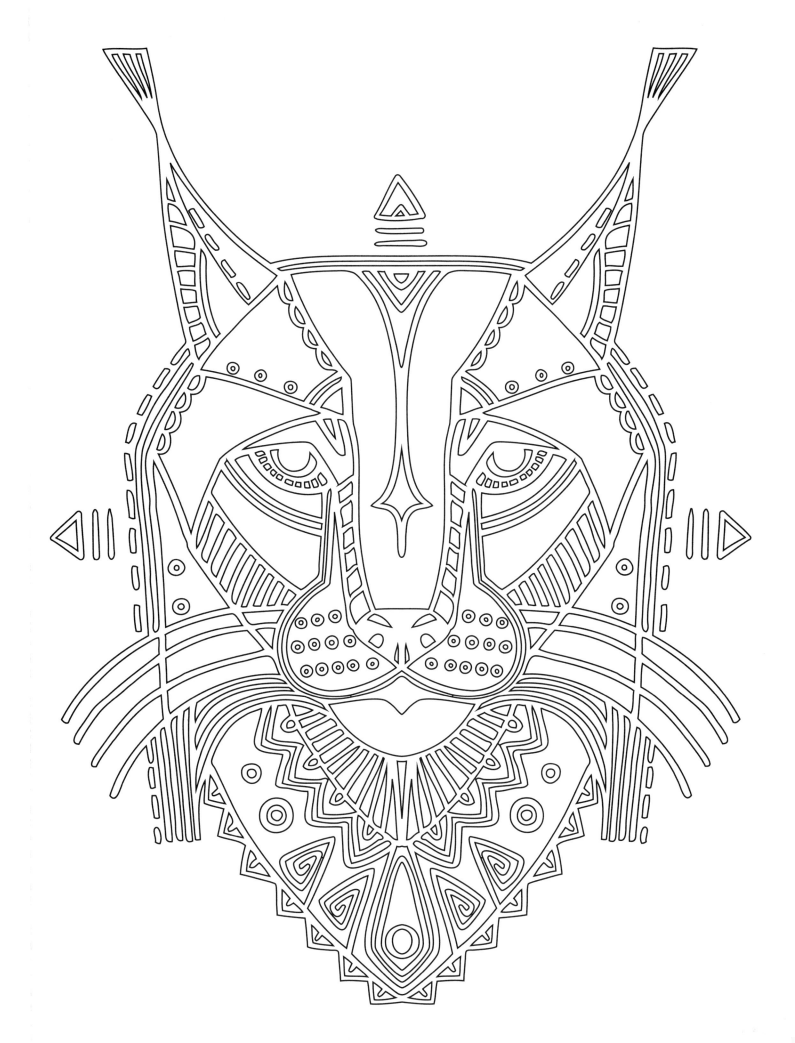

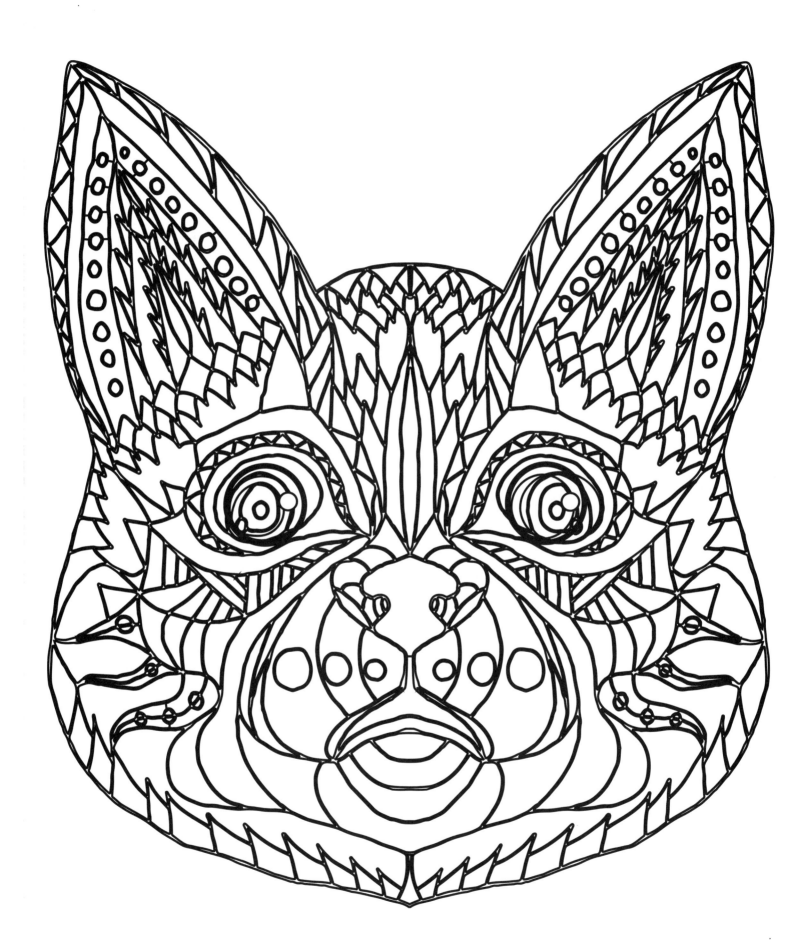

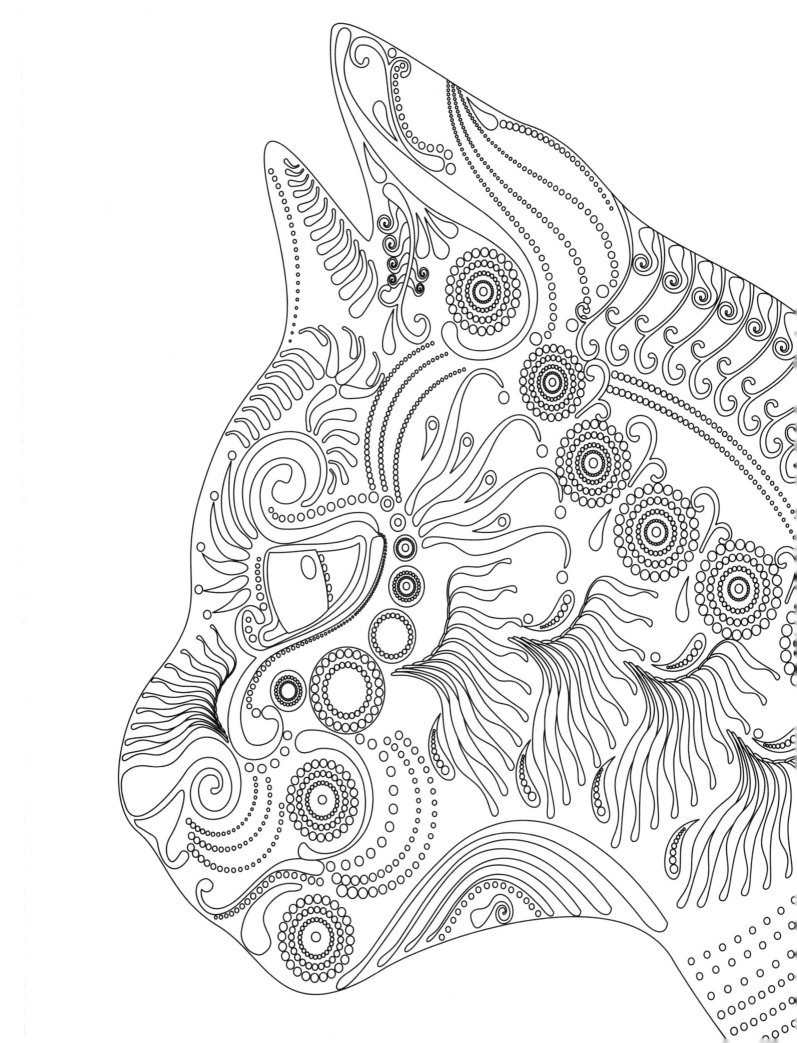

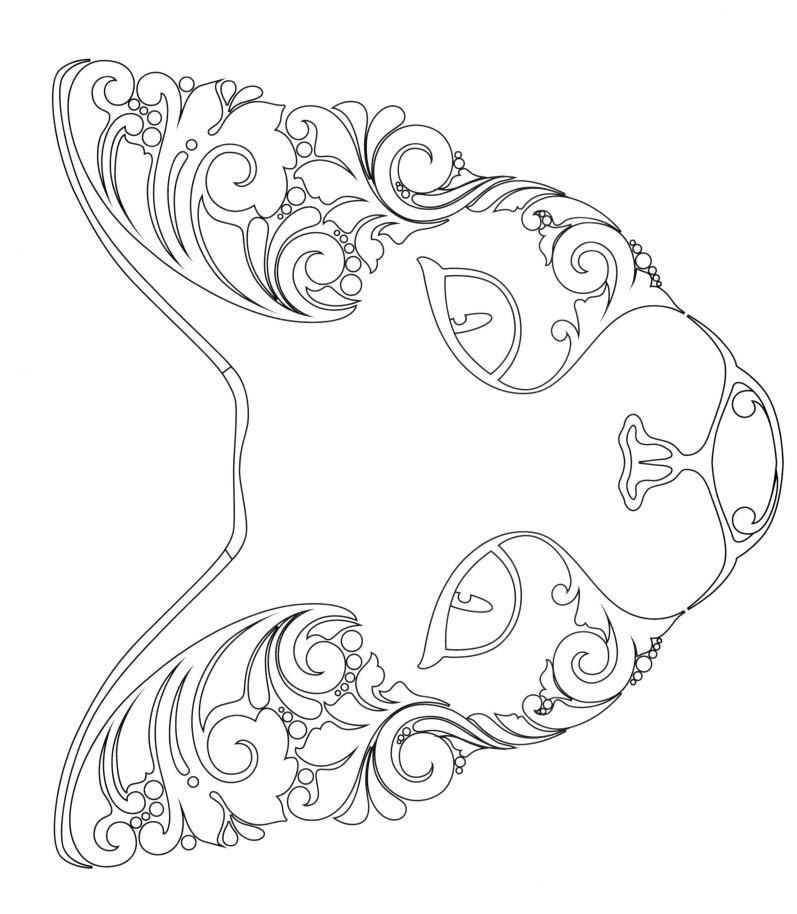

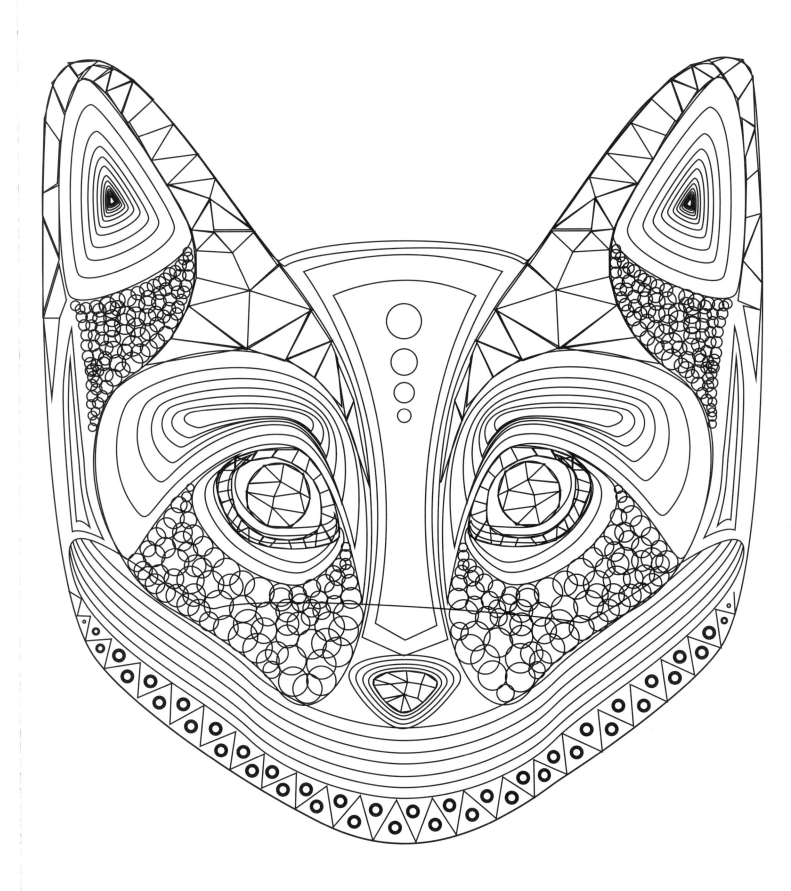

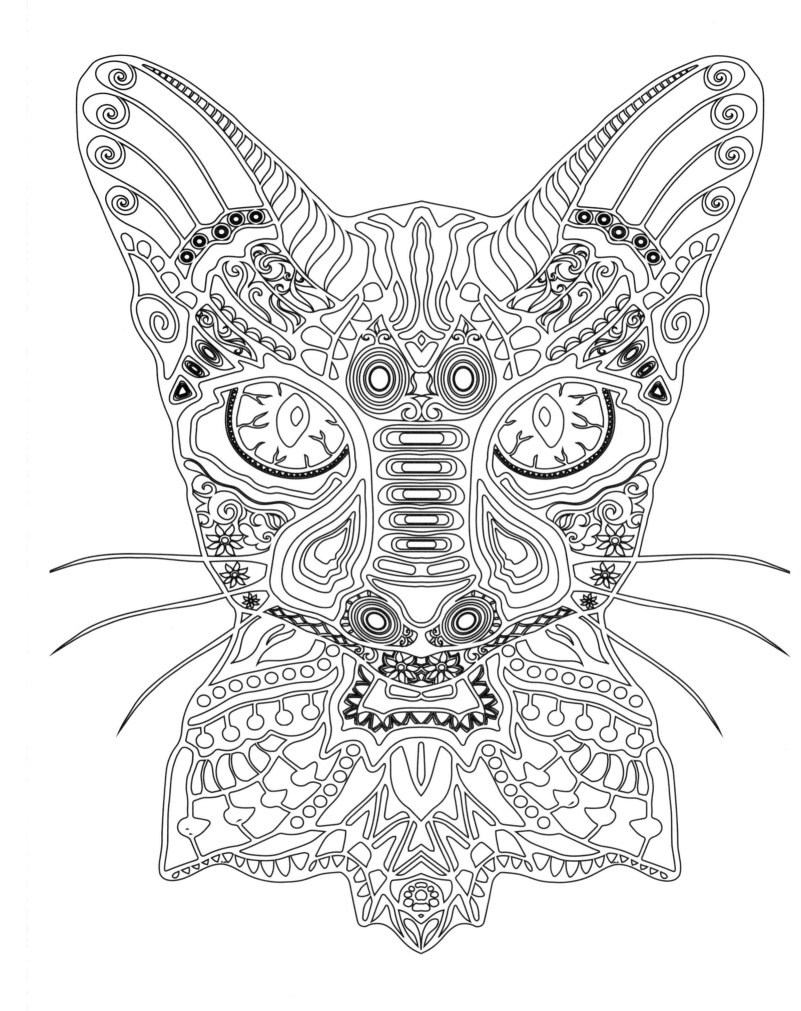

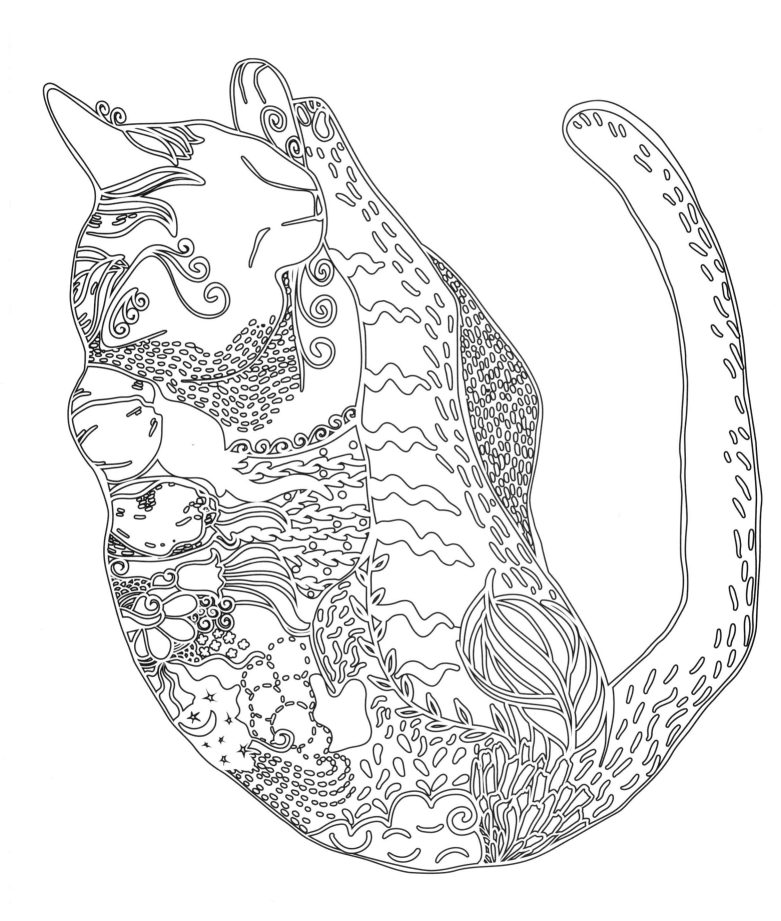

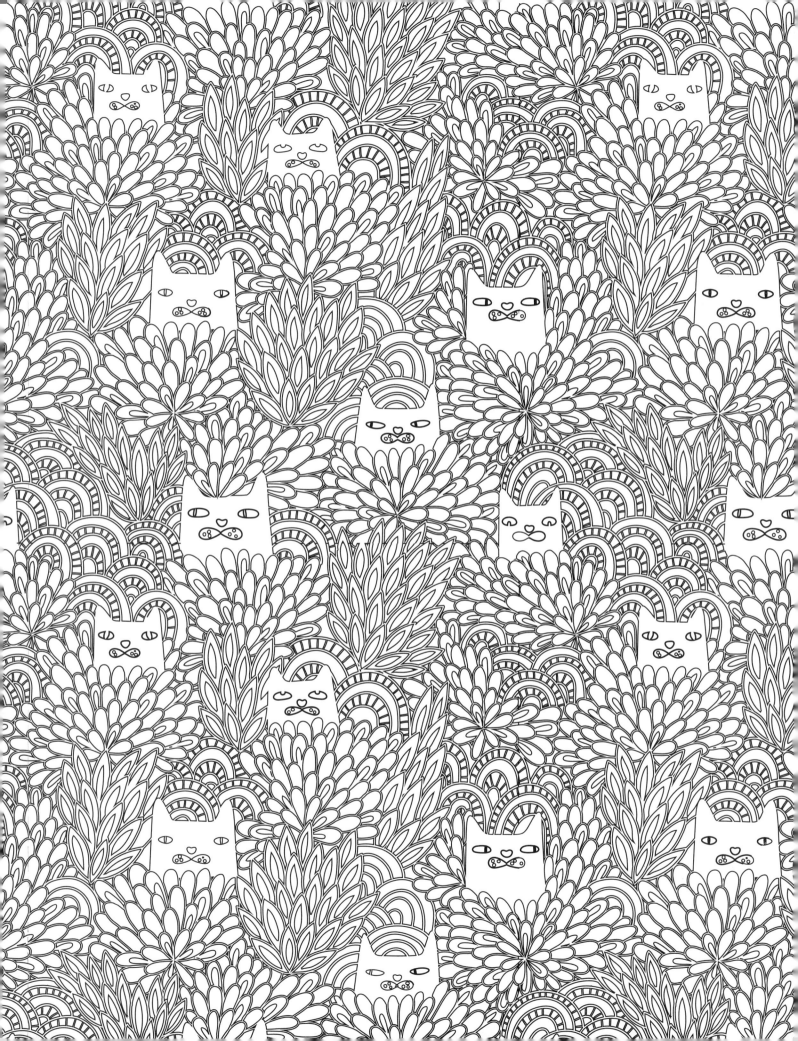

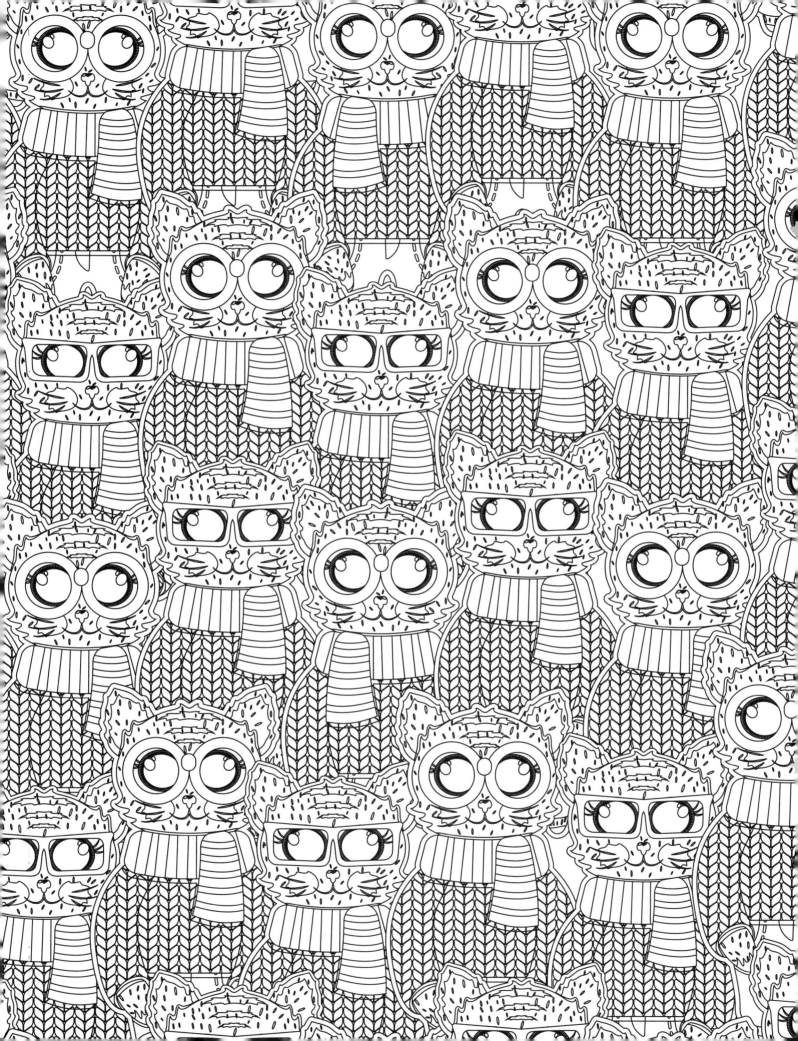

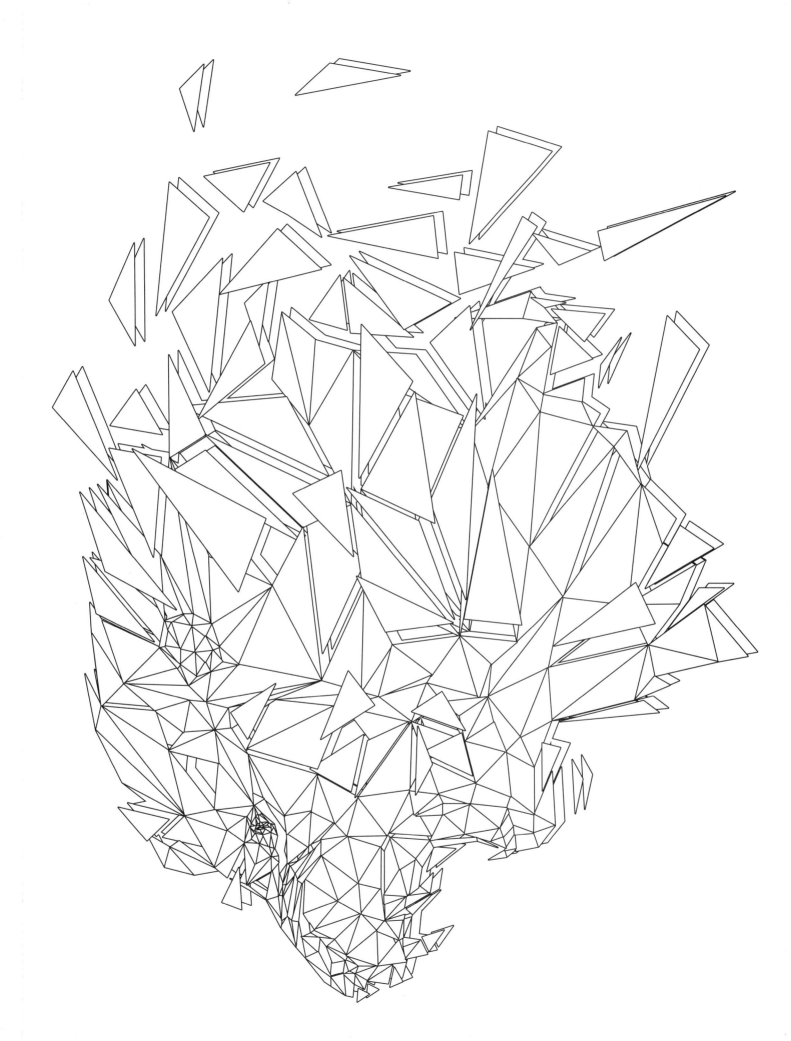

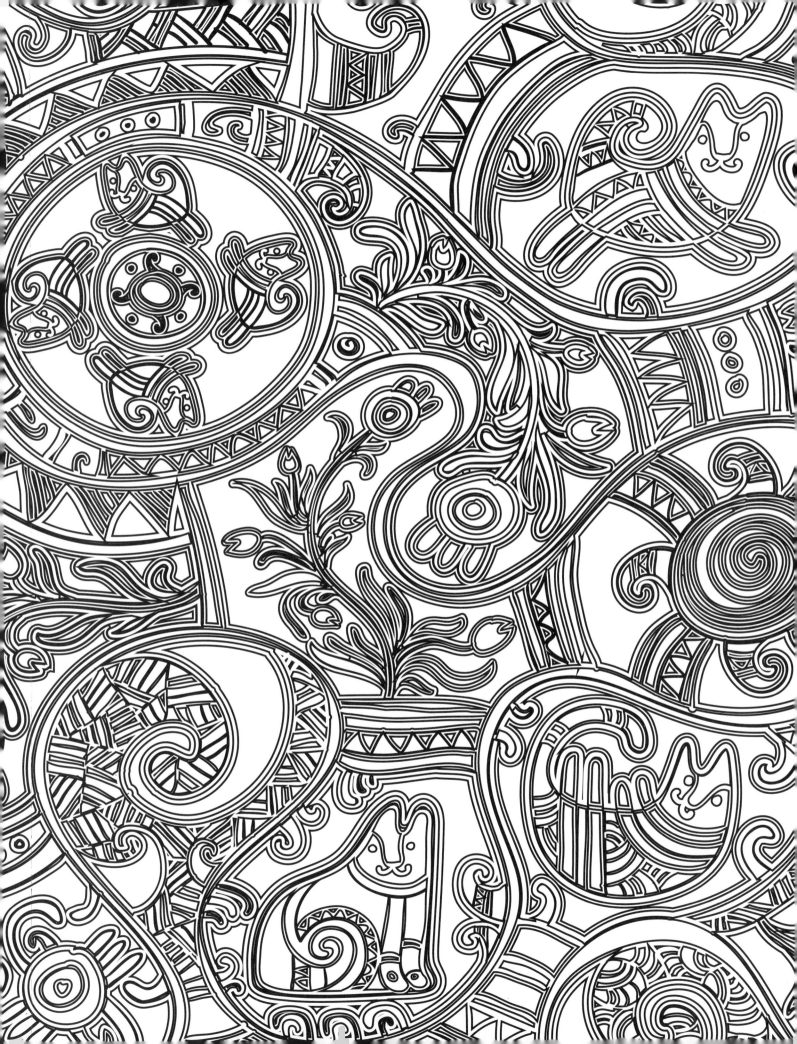

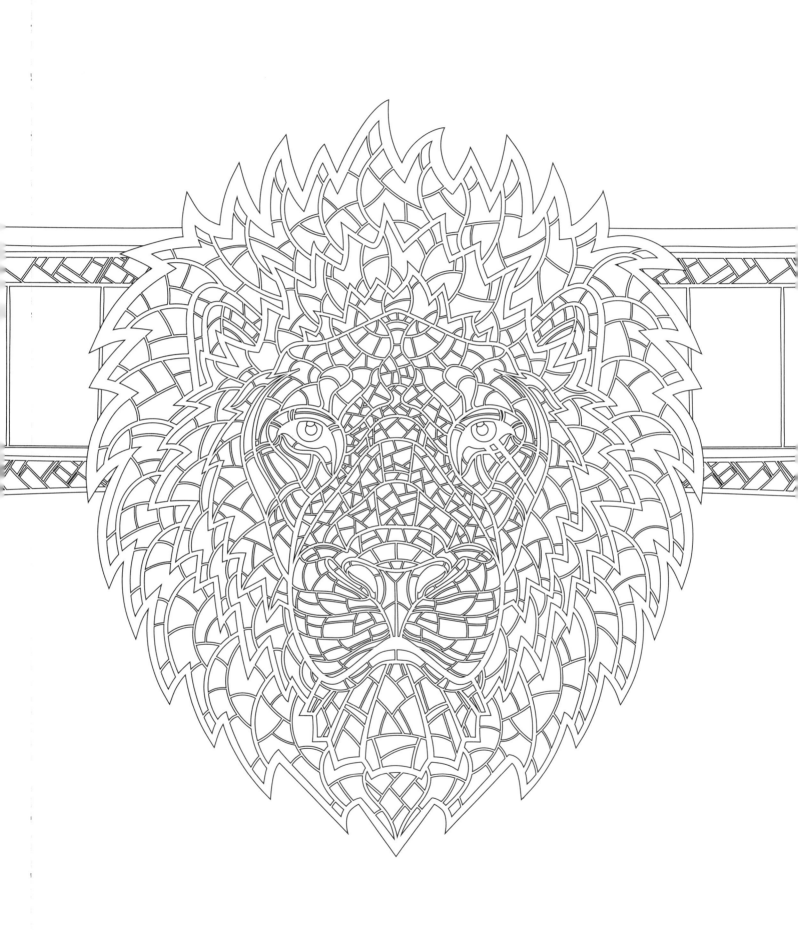

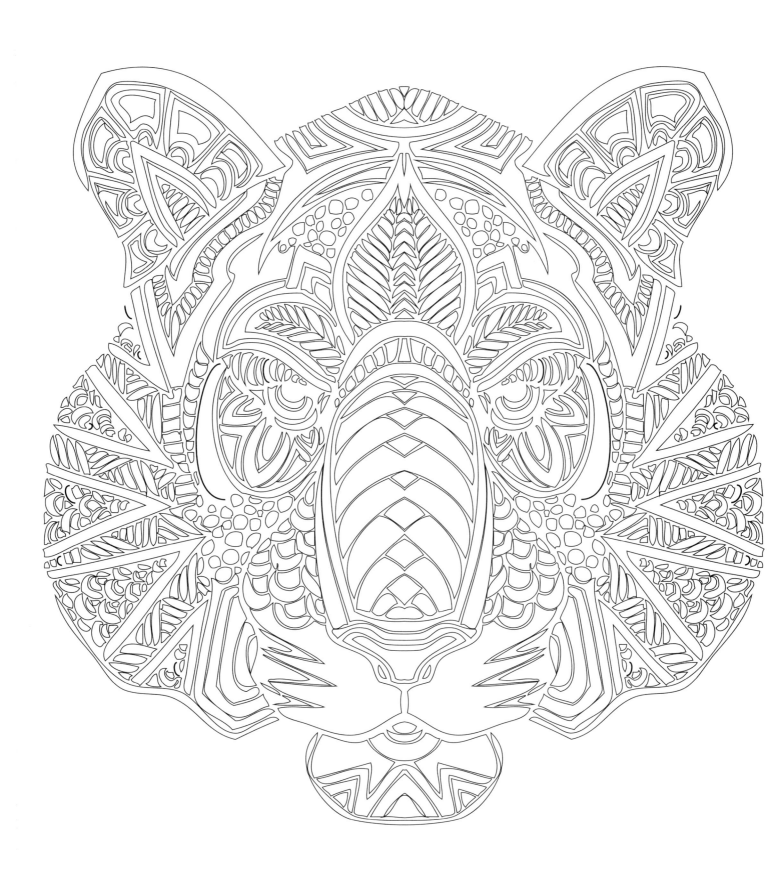

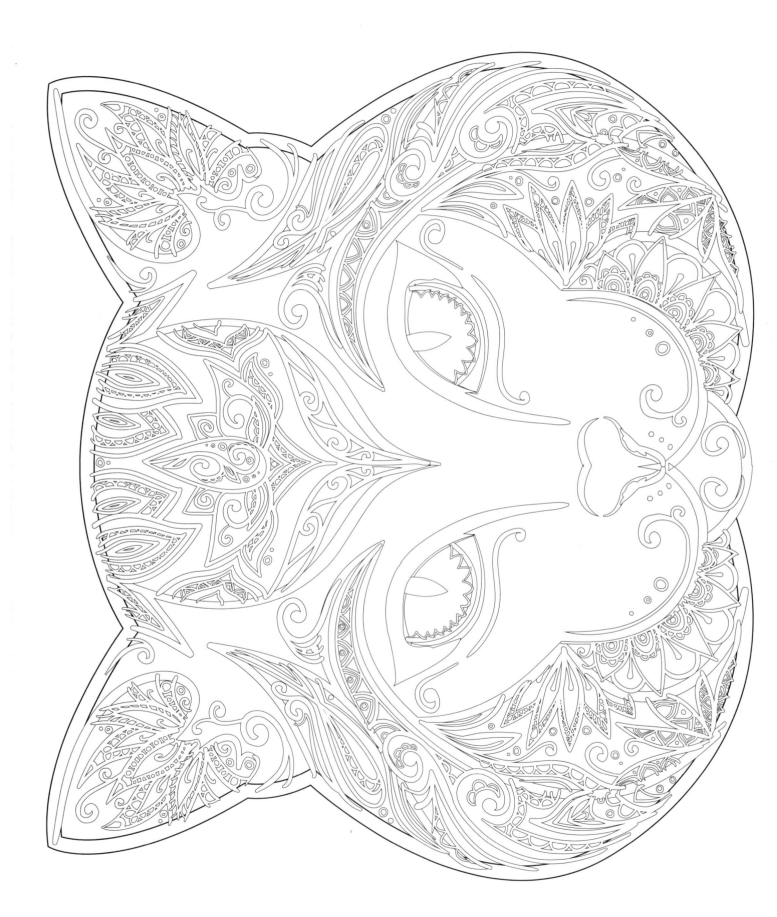

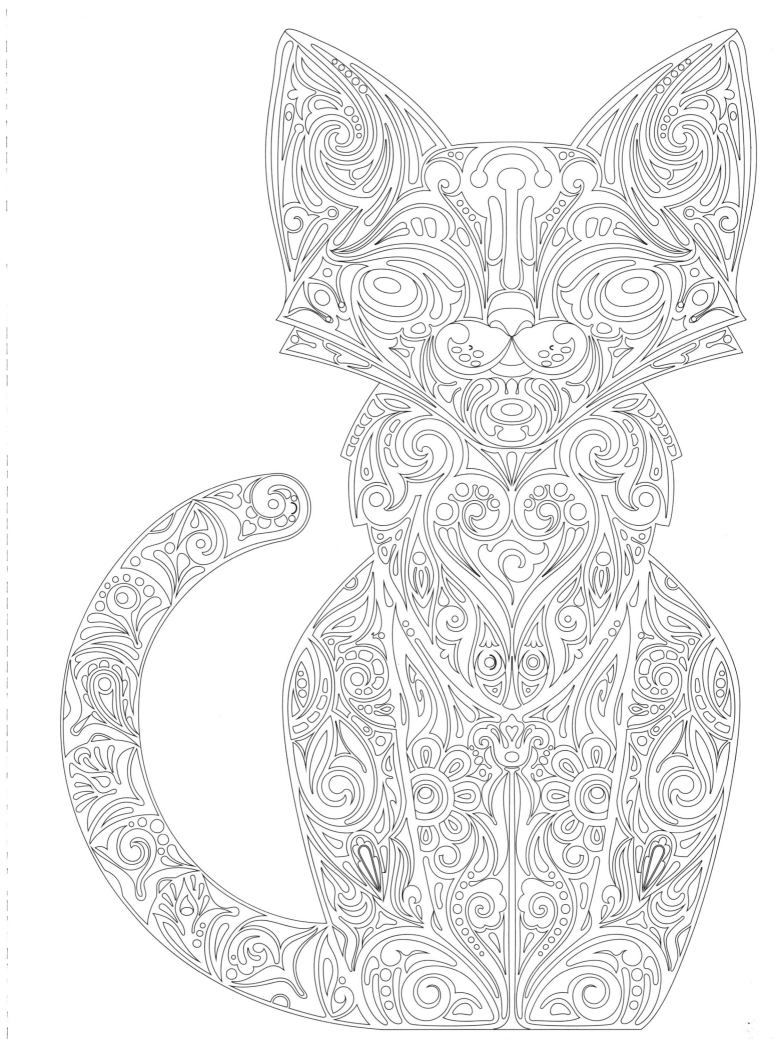

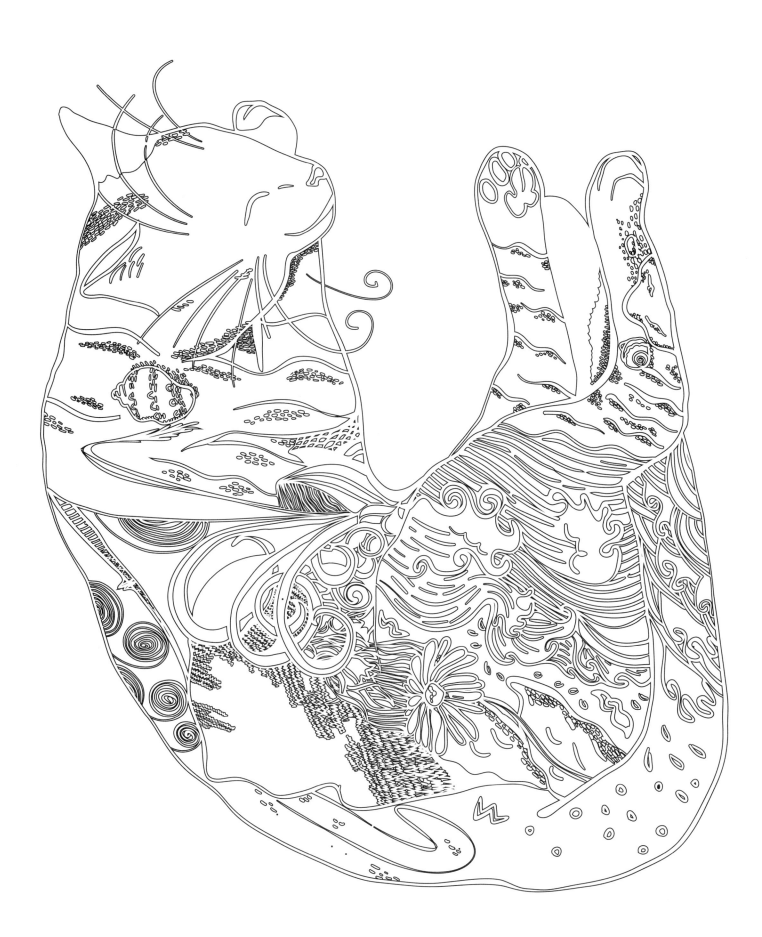

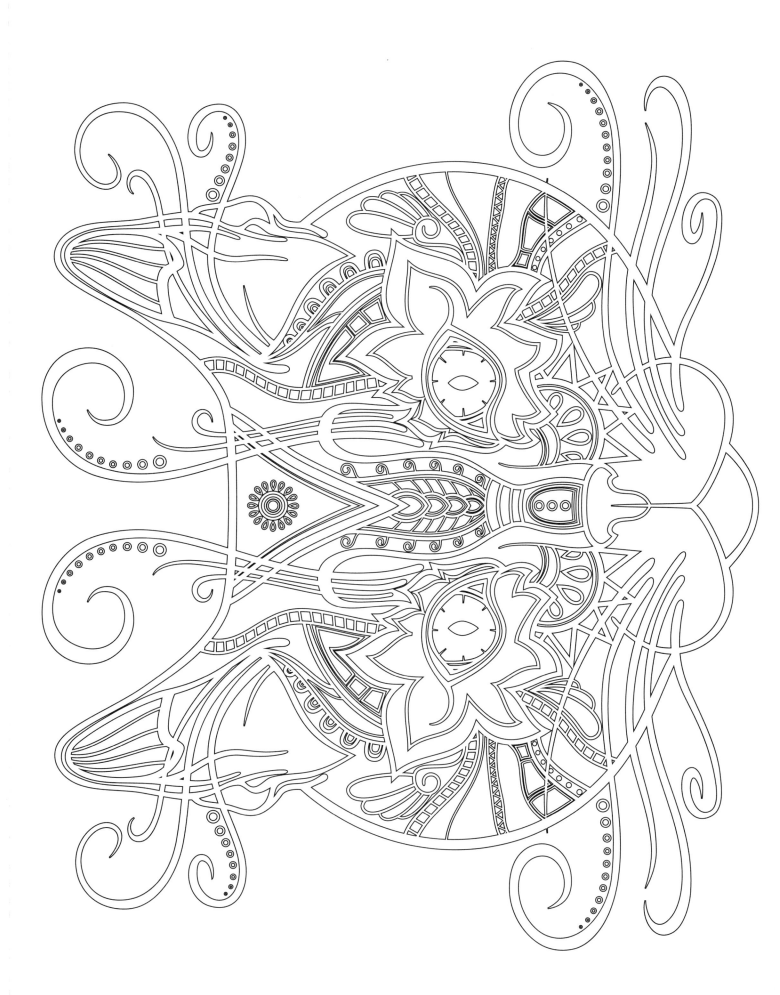

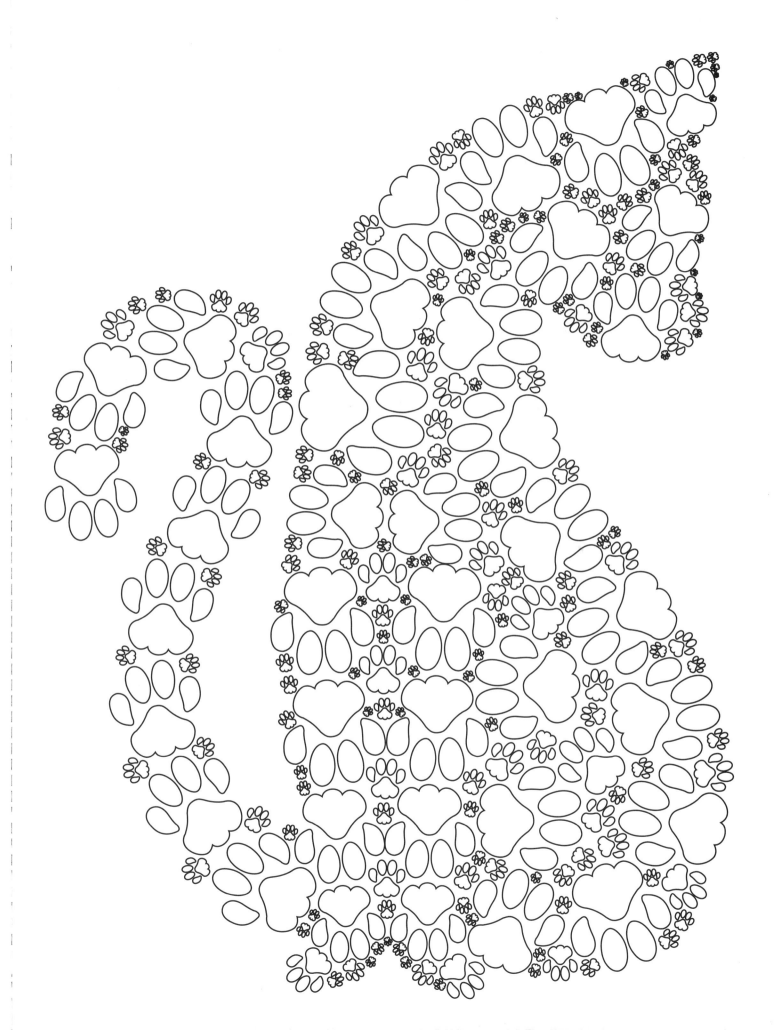

Color Bars

Use these bars to test your coloring medium and palette. Don't be afraid to try unique color combinations!

Color Bars

Color Bars

Also Available from Skyhorse Publishing

Creative Stress Relieving Adult Coloring Book Series
Art Nouveau: Coloring for Artists
Art Nouveau: Coloring for Everyone
Curious Cats and Kittens: Coloring for Everyone
Mandalas: Coloring for Artists
Mandalas: Coloring for Everyone
Mehndi: Coloring for Artists
Mehndi: Coloring for Everyone
Nirvana: Coloring for Artists
Nirvana: Coloring for Everyone
Paisleys: Coloring for Artists
Paisleys: Coloring for Everyone
Tapestries, Fabrics, and Quilts: Coloring for Artists
Tapestries, Fabrics, and Quilts: Coloring for Everyone
Whimsical Designs: Coloring for Artists
Whimsical Designs: Coloring for Everyone
Whimsical Woodland Creatures: Coloring for Artists
Whimsical Woodland Creatures: Coloring for Everyone
Zen Patterns and Designs: Coloring for Artists
Zen Patterns and Designs: Coloring for Everyone

The Dynamic Adult Coloring Books
Marty Noble's Sugar Skulls: Coloring for Everyone
Marty Noble's Peaceful World: Coloring for Everyone

The Peaceful Adult Coloring Book Series
Adult Coloring Book: Be Inspired
Adult Coloring Book: De-Stress
Adult Coloring Book: Keep Calm
Adult Coloring Book: Relax

Portable Coloring for Creative Adults
Calming Patterns: Portable Coloring for Creative Adults
Flying Wonders: Portable Coloring for Creative Adults
Natural Wonders: Portable Coloring for Creative Adults
Sea Life: Portable Coloring for Creative Adults